Welcome to this little book, it has been created to share with you the art of 'Doodling With Intent'. Through examples and space to experiment, it will help transform the humble doodle into a tool that can help y... stretch your creativity, rela... and pray.

'Almost all creativity involves purposeful play.'
(Abraham Maslow – Psychologist)

I have spent hours playing with my art! Doodling in meetings (it helps concentration!), trying out pens and papers, sketching views and messing with mixed media – I doodle freehand Celtic knots in pencil, pen, crayon, embroidery, willow and cord. It is all play, much of it won't be seen but all of it will inform

and inspire the artwork I create that will be seen.

Below and over the page is a quick tutorial on how to create a freehand knot – have a go!

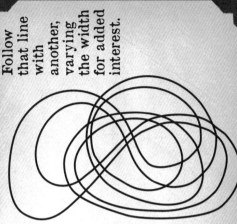

Start by doodling a meandering line which crosses over itself in several places (remember, no more than two lines crossing at any point) and make the line finish at its start.

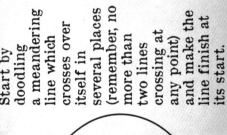

Follow that line with another, varying the width for added interest.

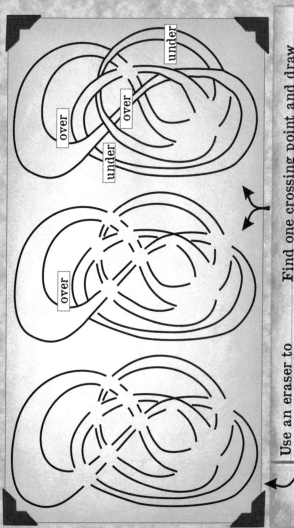

Use an eraser to remove where the lines cross over.

Find one crossing point and draw in the lines, then alternate lines over, lines under as you follow the knot.

over

over

over

under

under

under

The finished knot. Try adding words or pictures to this one then have a go at creating your own...

Create - to bring something into existence. (Dictionary definition.)

What a privilege it is to be able to create, to take a few disparate objects and make something new!

The doodle is a widely underestimated tool that can help you create - it may help us to organise our thoughts, express our emotions and release us from the sometimes overwhelming urge to make everything perfect!

a pencil

pens

paper

doodle = *scribble absent-mindedly*

A blank sheet of paper can be intimidating so start by messing up the surface...

This can be a great opportunity to try out old pens and paints.

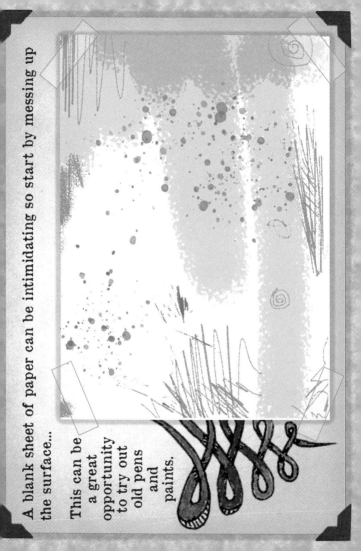

Try messing up the page below with light coloured pens, pencils or paint then doodle in darker colours and bold lines...

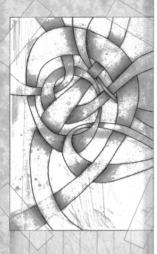

Relax – to make or become less tense or anxious.
(Dictionary definition.)

A study from Drexel University PA titled 'Functional near-infrared spectroscopy assessment of reward perception based on visual self-expression: Colouring, doodling, and free drawing', shows that the process of making art stimulates the area of the brain that is related to rewards - the same area that makes dancing, laughing, and eating sweet stuff so much fun.

Try doodling on scraps of assorted paper, cut them out and arrange, then stick them on the following pages, use glue or tape. have a go at theming the pages with just words or colours or shapes. Have fun!

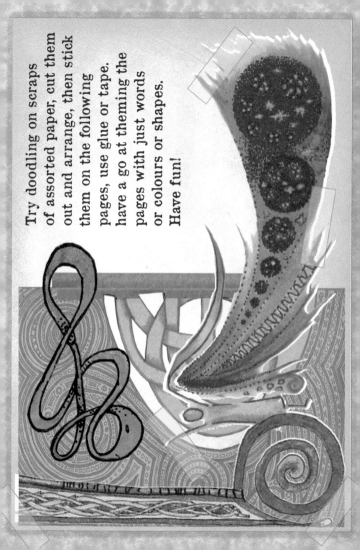

Sometimes, in the work I do, a word can spark the creative fire of a piece of artwork but often it is when I am doodling that ideas for writing will emerge. Words are powerful!

In this section there is space to doodle words; words from things you've read and single words that just pop into your head. There is space to experiment with forming letters and to play with words. Give yourself time to examine the words that you draw, what do they mean to you?

CONSIDER

Jesus

Consider... collecting fonts! I know, that sounds a little bit nerdy but if you're interested in drawing lettering it can be helpful to look at and copy examples around you.

On the following pages try writing words and letters in as many ways as possible, attempt to fill the pages, squish words in gaps between other words, make some really big and bold!

LET
THE
HEAVENS
BE
GLAD
LET THE
EARTH
REJOICE

UNDER IS THE GREAT AND WIDE SEA. THERE ARE MOVING THINGS INNUMERABLE LIVING CREATURES

LOVE

Change and shines like

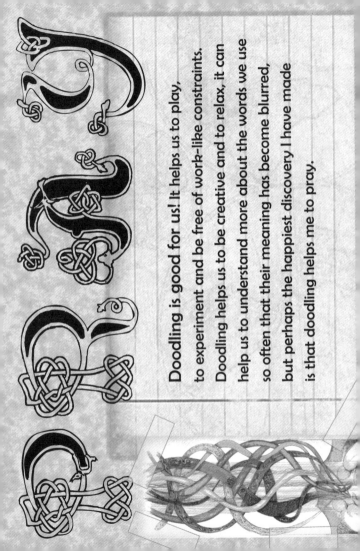

Doodling is good for us! It helps us to play,
to experiment and be free of work-like constraints.
Doodling helps us to be creative and to relax, it can
help us to understand more about the words we use
so often that their meaning has become blurred,
but perhaps the happiest discovery I have made
is that doodling helps me to pray.

As the lines are freely drawn, and the words are written, there can be a deliberate intent to invite God into the experience. At the moment of invitation a new conversation is begun with the Creator and God will speak through the doodles you create.

Use the last pages to weave knots, make patterns, write significant words and of course, doodle. You could say this prayer before you begin:

Creator God, I give this time to You,
Help me to be creative.
Surround me with Your presence
Speak through my doodles
and help me to hear You.

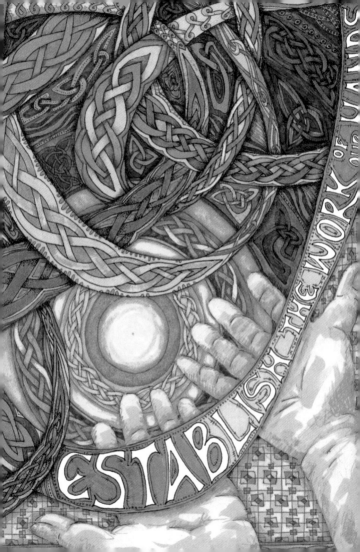